CURATORS' CHOICE
TELFAIR MUSEUMS

TELFAIR MUSEUMS

Dale C. Critz, Jr.
Anne-Solène Bayan
Shannon Browning-Mullis
Harry H. DeLorme
Erin Dunn
Courtney A. McNeil

PUBLICATION SPONSOR
Telfair Academy Guild

SCALA

INTRODUCTION

When your museum has been exhibiting and collecting exceptional works of art for more than 130 years, it's no easy task to pick and choose the very best of the best. The works featured in this book—selected by our excellent curators from Telfair Museums' permanent collection of over seven thousand objects—necessarily offer an incomplete view of our institutional history. But they also present a compelling one. When Mary Telfair established our museum in 1875, did she have any idea what lay ahead?

Today, Mary Telfair's converted Regency-style mansion is the Telfair Academy, a National Historic Landmark designed by the British architect William Jay, now part of Telfair Museums' holdings in Savannah, Georgia. The Owens-Thomas House & Slave Quarters was acquired by Telfair Museums in 1951 at the bequest of Margaret Thomas. Together with the contemporary Jepson Center, completed in 2006 and named in honor of donors Alice and Bob Jepson, these unique buildings present dozens of exhibitions and welcome more than 250,000 visitors from all over the world each year.

The museum's collection, with its vigor and variety, reflects this winding and eclectic time line. Shaped first in the late nineteenth century by Carl Brandt, our founding director who had a taste for traditional European art, it was later transformed in the early twentieth century by his successor Gari Melchers, whose passion for the contemporary and inventive movements of his time brought major works of American impressionism and the Ashcan School. The museum's extensive decorative

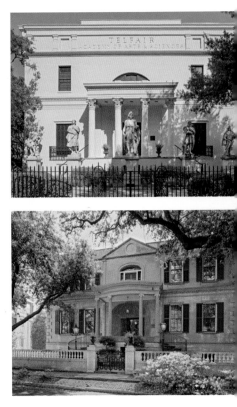

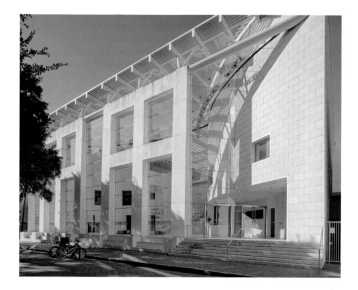

arts collection, initially assembled with the goal of ornamenting period rooms in the historic buildings, has blossomed to include exhibitions on ceramics, furniture, and metalwork. A renewed collecting effort in the 1990s and 2000s greatly diversified Telfair's contemporary holdings by adding unique works in mediums such as photography, textiles, and the digital arts.

Telfair Museums has been an important part of my life since my childhood, and as Chair of Telfair's Board of Trustees, I am so proud to introduce this selection of our curators' favorite works of art. I hope Telfair becomes an important part of your life, too.

Dale C. Critz Jr.

Robert Henri
American, 1865–1929

La Madrileñita (The Girl of Madrid), 1910

Oil on canvas, 41 × 33 ³⁄₁₆ in. (104.1 × 84.3 cm)

Museum purchase

1919.1

AMERICAN ARTIST ROBERT HENRI is known for vibrant portraits of individuals he encountered on his extensive travels through the United States and Europe. Based in New York for most of his career and active as a teacher at William Merritt Chase's New York School of Fine and Applied Art (now known as Parsons) and the Art Students League, Henri spent his summers traveling in search of inspiration. He ventured to Ireland, the Netherlands, Maine, California, and New Mexico, but the country he visited more than any other was Spain. Henri first visited Spain in 1900 and returned six additional times before his death in 1929, producing paintings of Spanish bullfighters, dancers, musicians, and gitanos (members of the Romani ethnic group).

This three-quarter view of Spanish dancer Josefa Cruz was the first of several portraits Henri painted of her. The subject's clear gaze meets the viewer's eye and dynamic gold and green highlights enliven the canvas, suggesting that although the dancer is shown at rest, she will soon resume her movement. Painted in Spain in 1910, the work was acquired by Telfair Museums directly from the artist in 1919. In a letter to the museum at the time of the purchase, Henri remarked, "I take great pleasure in the honor of having one of my pictures in the Telfair collection, and I feel that you will have in the picture '*Madrileñita*' one of the very best things I have painted." He went on to describe the subject, saying "it seemed to me she had in her carriage...much of the spirit and dignity of old Spain." CAM

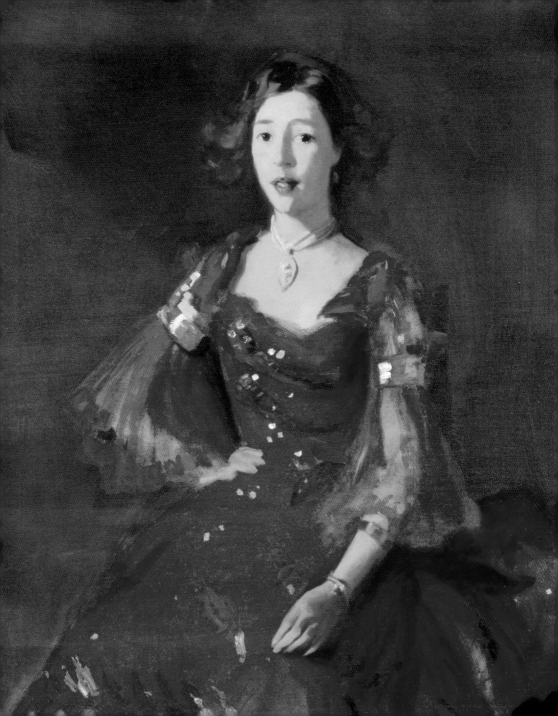

AUGUSTA SAVAGE
American, 1892–1962

Gwendolyn Knight, c. 1937

Bronze, 17 ⁵⁄₁₆ × 8 ½ × 8 in. (44 × 21.6 × 20.3 cm)

Gift of the Walter O. Evans Collection of African American Art

2003.18

AUGUSTA SAVAGE LEFT A LEGACY in American art, both in her work as a sculptor and through a generation of artists who she shaped as a teacher and role model. Born near Jacksonville, Florida, in 1892, Savage made clay figures as a child and in high school was already teaching clay modeling to other students. After a relocation to New York, she studied at Cooper Union in 1921. Despite a racially motivated denial of an opportunity to attend the Fontainebleau School of the Arts in France, Savage eventually earned a Rosenwald Fellowship that allowed her a year's study in Paris. Returning to New York, she put her professional training to good use for the benefit of other artists, becoming an influential teacher and cultural figure of the Harlem Renaissance. She established the Savage Studio of Arts and Crafts, which became an essential training ground for many artists who would later have notable careers, among them the painter Gwendolyn Knight (1913–2005), portrayed here in bronze. This sensitive bust captures the young Knight during the four-year period when she was regularly taking classes at Savage's school. The work was first exhibited in 1935 at the Harlem YWCA as a plaster cast painted to look like bronze. Savage seldom had the means to cast her own work in bronze, a more permanent medium, and this example was cast posthumously. Savage went on to become director of the Harlem Community Arts Center and she received acclaim for a large-scale commission for the 1939 New York World's Fair, a sculpture inspired by James Weldon Johnson's "Lift Every Voice and Sing." HD

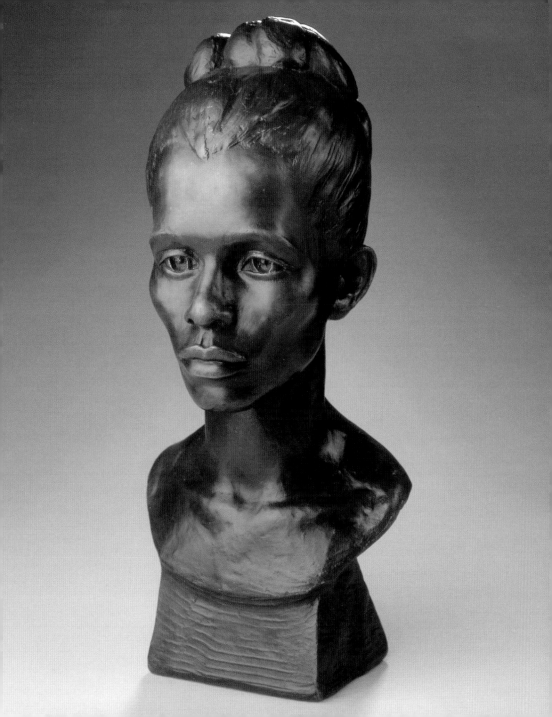

JULIAN RUSSELL STORY
American, born England, 1857–1919

The Black Prince at Crécy, 1888

Oil on canvas, 128 × 197 in. (325.1 × 500.4 cm)

Bequest of Carl L. Brandt

1905.2

THIS MONUMENTAL CANVAS stands more than ten feet tall and is a prime example of the type of large-scale narrative history painting popular in academic circles during the Telfair Museums' founding. The painting earned admission into two major exhibitions in Paris: the 1888 Salon and the 1889 Exposition Universelle. Artist Julian Russell Story depicts the aftermath of the 1346 Battle of Crécy during the Hundred Years' War. The central figure is the victorious Prince of Wales, Edward, often referred to as the Black Prince due to his preference for dark armor. Edward stands over the body of his slain opponent, King John of Bohemia, an ally of the French, who rode into battle alongside his troops despite being blind. Out of respect for his fallen adversary, Edward adopted John's motto, *Ich dien* (I serve), and it remains the motto of the United Kingdom's Princes of Wales today.

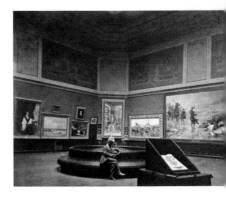

The Black Prince at Crécy is one of many academic history paintings acquired for Telfair Museums by its first director, Carl Brandt. The museum's founder, Mary Telfair (1791–1875), bequeathed her home and much of her family's fortune to establish the Telfair Academy of Arts & Sciences, but she did not have a significant art collection. It was therefore left to Brandt to oversee both the conversion of the private Telfair home into a public art museum and to assemble its founding collection, which he did over the course of his tenure from 1883 until his death in 1905. Notably, Brandt purchased this painting directly from the artist in 1889 with his own funds and, as seen in this photograph, put it on view in the rotunda of the Telfair Academy. He bequeathed it to the museum in his will. CAM

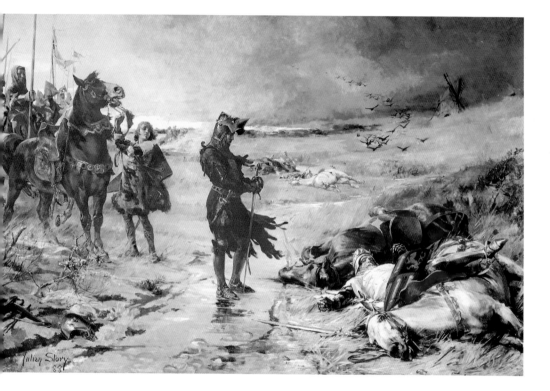

CHILDE HASSAM
American, 1859–1935

Avenue of the Allies, 1917

Oil on canvas, 18 ⅛ × 15 ³⁄₁₆ in. (46 × 38.6 cm)

Bequest of Mrs. Elizabeth Millar Bullard

1942.11

AMERICAN IMPRESSIONIST CHILDE HASSAM was firmly established as one of the most critically and commercially successful artists of his day when he embarked on his now-iconic series of flag paintings. Inspired by the flag displays on New York's Fifth Avenue in the months leading up to the United States' entry into World War I, Hassam created approximately thirty flag paintings from 1916 to 1919. He also treated the subject in a 1918 lithograph (see figure), which replicates the composition of his painting *Avenue of the Allies: Brazil, Belgium* (now in the Los Angeles County Museum of Art). This body of work is often interpreted as a personal expression of Hassam's patriotism and his support for France (where he studied and lived for several years) and for Britain (the country to which he proudly traced his heritage).

This painting was originally exhibited by Hassam under the title *Flags at the Waldorf*. It depicts the flags of France, the United States, and the United Kingdom displayed on the facade of the original Waldorf-Astoria hotel, with the sunlit columns of the Knickerbocker Trust and Safe Deposit Company in the background. Constructed in 1893 and expanded in 1897, the Waldorf-Astoria was demolished in 1929 to make way for the Empire State Building. Unlike other paintings in Hassam's flag series, this one takes a tighter view, cropping the architecture dramatically and not revealing any open sky in the background. Telfair trustee Mrs. Elizabeth Millar Bullard acquired this painting, most likely from a 1918–19 exhibition held at Milch Gallery in New York, and bequeathed it to the museum in 1942. CAM

ABOVE:
Childe Hassam
(American, 1859–1935)
Avenue of the Allies, 1918
Lithograph on paper,
12 ⅝ × 6 ⅞ in.
(32.1 × 17.5 cm)
Gift of Mrs. Childe Hassam
through Frank P. Crasto,
1940.13.13

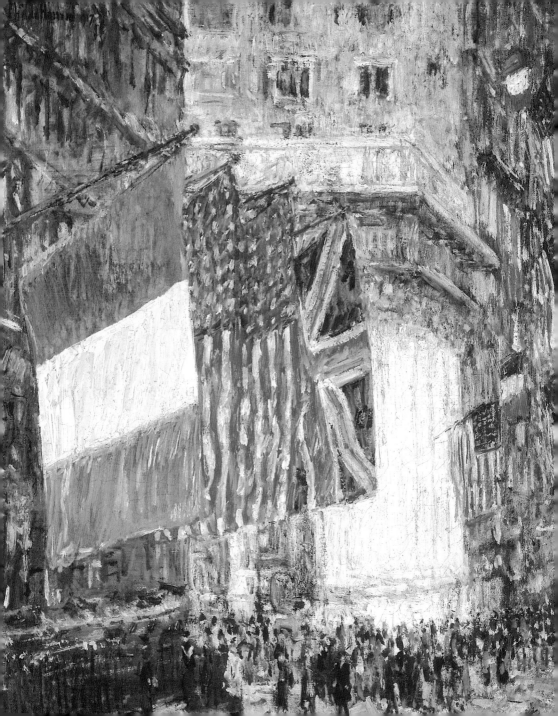

GEORGE BELLOWS
American, 1882–1925

Snow-Capped River, 1911

Oil on canvas, 45 ¼ × 63 ¼ in. (114.9 × 160.7 cm)

Museum purchase

1911.1

GEORGE BELLOWS WAS ONE OF THE best-regarded painters of his generation, making an enduring mark on American art despite his premature death at age forty-two from a ruptured appendix. Known for his paintings of boxers, which challenged notions of acceptable fine art subject matter while celebrating traditional ideals of masculinity, Bellows was born in Columbus, Ohio, and went to New York in 1904 to study art with William Merritt Chase and Robert Henri.

Snow-Capped River, like many of Bellows's urban landscapes, portrays New York during the winter. The painting presents a view from Manhattan's Riverside Park of the icy Hudson River and the snowy Palisades of New Jersey in the distance. Bellows applied his paint thickly, in some places using a palette knife rather than a paintbrush. At first glance, the color palette seems to be composed of blues and greens, but closer examination reveals vibrant yellows, saturated violets, and small pops of red that draw the viewer's eye around the canvas. The composition is tightly structured, with a tall tree on the left and a stone wall at the bottom creating a distinct rectangle. The work is grounded by a vignette of everyday city life in the foreground: a man pauses during his morning walk to tie his shoe on a park bench, his large dog's attention captured by a smaller dog pulling on its leash nearby.

This work was painted in 1911 and acquired by Telfair Museums that same year through negotiations between Bellows and Gari Melchers, Telfair's fine arts adviser. Bellows counted it among his most important works. CAM

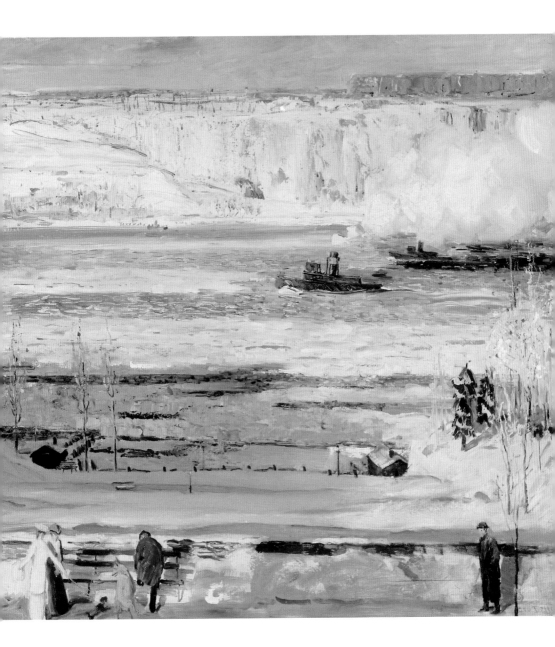

ANSLEY WEST RIVERS
American, born 1983

Nuclear Power Plant, Altamaha River, Georgia,
2014 (printed 2020)

Archival pigment print, 40 × 50 in. (101.6 × 127 cm)

Museum purchase with Telfair Museum of Art acquisitions endowment funds

2019.34.1

AFTER A KAYAKING TRIP through the Grand Canyon, Ansley
West Rivers resolved to document the history and importance
of American waterways. She challenged herself to photograph
seven rivers—from source to sea—across the United States.
Using photography's inherent capacity to mark time, West
Rivers captures the state of water in its current moment; she
holds a mirror to the beauty and degradation of these North
American watersheds and prompts a reflection on changes to
water sources in the United States and around the globe.

Nuclear Power Plant, Altamaha River, Georgia captures the
Altamaha River, which winds its way through West Rivers's
native Georgia and into the Atlantic. The river is a largely
untouched body of water that boasts an incredibly rich eco-
system, but it is threatened by encroaching industry. This
photograph embodies West Rivers's unique process using a
large-format camera. She creates multiple compositions on a
negative plate by shooting several exposures onto each frame
with the help of masking tools, which are placed in front of
the lens. The tools allow her to avoid double exposures, and
all imagery is made in-camera rather than in postproduction.
The magic of her process is revealed in the photograph as
water floats ethereally above the solid tower of the power
plant. This constructed scene reminds the viewer of the ten-
uous line between protection and destruction. The views do
not exist as real vistas, but they offer a new vision for the
beholder. Straightforward river scenes are transformed into
complicated, artistically masterful, and sublime views that
reveal the complexities affecting fresh water and the effects
of unbridled human activity on nature. ED

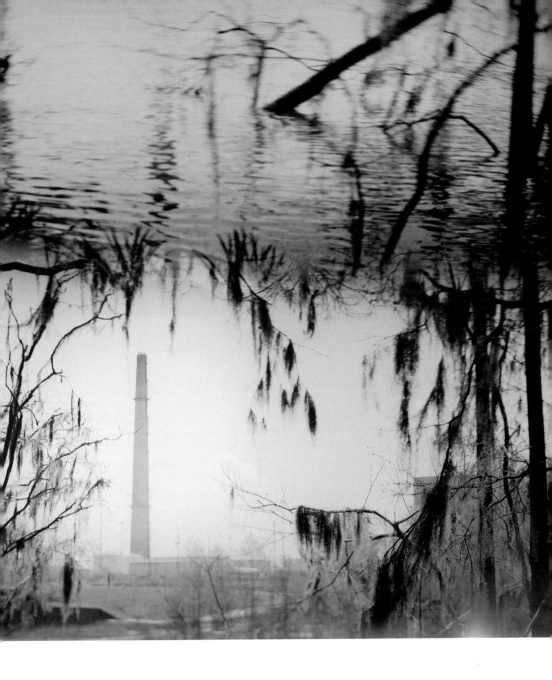

Andrée Ruellan
American, 1905–2006

Savannah, c. 1942
Oil on canvas, 26 × 36 ½ in. (66 × 92.7 cm)
Museum purchase
1998.8

In a letter to a Telfair curator in 1997, artist Andrée Ruellan recalled, "Savannah and Charleston were revelations to me and greatly influenced my work." Born in New York to French parents, Ruellan excelled in art from an early age, receiving an invitation to exhibit with noted American artist Robert Henri when she was only nine years old. She attended the Art Students League and later studied in Rome and Paris, where she met and married American artist John W. Taylor. Ruellan and Taylor settled in Shady, New York, and participated in the artists' colony in nearby Woodstock. At the suggestion of colleagues, they traveled south, visiting Charleston in 1936 and Savannah in 1941.

In Savannah, Ruellan and Taylor made sketches, which they later developed into larger oil canvases in their studio at Shady. Ruellan was particularly fascinated by the Savannah River and the city's old market building. *Savannah* depicts the river as glimpsed between buildings that flank the cobblestoned Barnard Street ramp, leading down to the wharves. Cleanly defined shapes and flat patches of color and value reflect Ruellan's awareness of abstraction, while figures capture the cadence of daily life along the river.

The serenity of the image belies a time of increased activity on the Savannah waterfront: as the United States moved closer toward war, there were concerns about spying near the city's shipyard. Once, while sketching from their car near the river, Ruellan and Taylor were suspected of espionage and detained by police. A friend, Alexander Brook, who anchored a colony of artists in Savannah's riverfront warehouses, vouched for the couple, who were released. HD

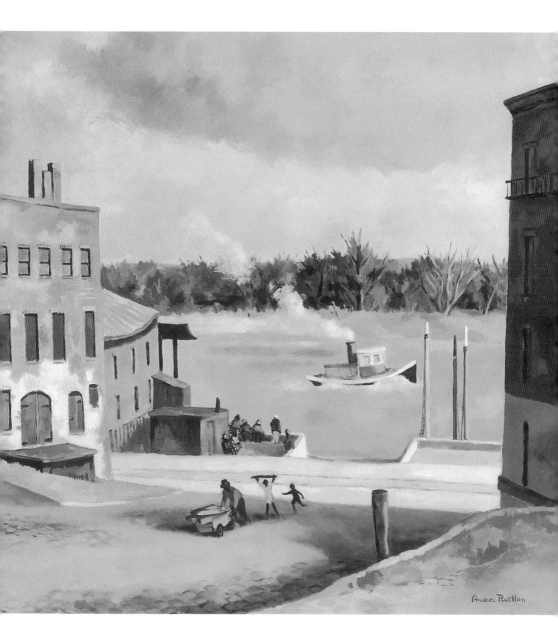

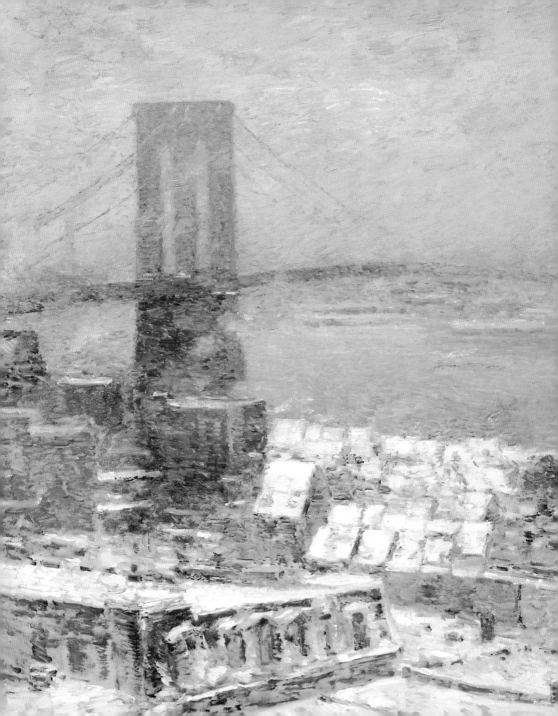

CHILDE HASSAM
American, 1859–1935

Brooklyn Bridge in Winter, 1904

Oil on canvas, 30 × 34 ³/₁₆ in. (76.2 × 86.8 cm)

Museum purchase

1907.2

CHILDE HASSAM WAS BORN in Boston and spent several forma-
tive years studying and working in Paris, but he is best known
for his images of New York, the city he would call home for most
of his career. In his 1904 painting *Brooklyn Bridge in Winter*,
Hassam portrays the distinctive architecture of the bridge
shrouded in swirls of snow. In the foreground, various build-
ings and rooftops are unified by a light coating of snow. The
bridge, which had been under construction from 1870 until 1883,
was widely regarded as a triumph of contemporary design and
engineering. In Hassam's own words, "We are a great indus-
trial nation, but we are also an artistic one. Look at some of our
great buildings, our bridges and viaducts. They in themselves
are works of art."

This example of American impressionism entered the col-
lection of Telfair Museums in 1907 and marked a seismic shift
in the type of art collected by the institution. One of the very first
purchases made for the museum by its new fine arts adviser,
Gari Melchers, this modern painting differed in style, subject,
size, and nationality from the sober, academic, and almost
entirely European works collected by the museum's founding
director, Carl Brandt (see pp. 10–11 for an example of work col-
lected by Brandt). Melchers and Hassam were lifelong friends,
so it is unsurprising that Melchers would turn to Hassam's
work as he sought to expand Telfair's collection, introducing
some of the better-known American artists of the day. CAM

WALTER MACEWEN
American, 1860–1943

The Lacemakers, *c.* 1885–1900

Oil on canvas, 22 ⅞ × 38 ¾ in. (58.1 × 98.4 cm)

Gift of Mr. and Mrs. George A. S. Starke, Jr., and family

1992.2

TRAINED AT THE ROYAL ACADEMY in Munich and later at the Académie Julian in Paris, Chicago native Walter MacEwen spent the majority of his life as an expatriate in Europe, returning to the United States only to flee war in 1939. Originally destined to helm the family business—his father's contracting firm—MacEwen changed course after an unusual introduction to the arts; a destitute painter, in pursuit of a small loan, left his brushes and paints to the firm as collateral and never returned to claim them. By the mid-1880s, the improbable artist had left the United States and established studios in Paris and the Netherlands, even settling for a time in the small Dutch village of Hattem.

Like many artists of his time, MacEwen was drawn to the Netherlands for its idyllic landscapes, its seemingly unchanging village life, and its celebrated artistic past. The influence of seventeenth-century Dutch painter Johannes Vermeer—his naturalist handling of paint and incomparable depictions of domestic inner lives—is apparent in MacEwen's work. In *The Lacemakers*, three women are shown in traditional costume, tatting the edges of a large piece of white fabric. The figure at left has temporarily suspended her work and rests her elbow on a wooden chair. This introspective atmosphere, a touchstone of many Dutch old masters' works, is further suggested through the characters' contemplative gazes and the stillness of their poses. One can feel the quiet of the room, punctured only by the hum of the women at work, the man's pipe smoking, and the bustle of the city through the open glass windows. ASB

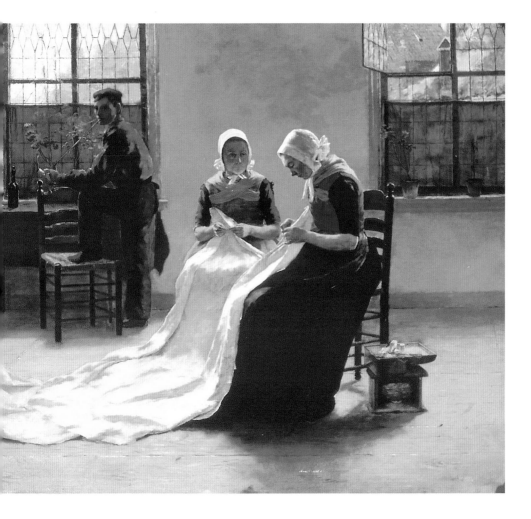

MARY HOOVER AIKEN
American, 1905–1992

Café Fortune Teller, 1933
Oil on canvas, 33 ⅝ × 28 ⅞ in. (85.4 × 73.3 cm)
Gift of friends of Mary Hoover Aiken
1975.3

AN ACCOMPLISHED AMERICAN ARTIST known for her vibrant land-scapes and portraits, Mary Hoover Aiken was born in Cuba, New York. She excelled at art, studying in the 1920s at the Corcoran School in Washington, DC, and with prominent painters Charles Webster Hawthorne and George Luks in Provincetown and New York, respectively. After studies in France and Germany, she became the assistant to the Spanish painter Luis Quintanilla, working on murals in Madrid in the early 1930s.

Although reminiscent of American Scene painting, *Café Fortune Teller* was completed on the Spanish island of Ibiza. This self-portrait shows the artist reading fortunes amid the bustle of a café in Santa Eulalia, where she lived for nearly two years as troubles brewed ahead of the Spanish Civil War. In the background, men sit with their heads in their hands and converse over drinks, the sense of dread palpable. Many of the men were fishermen drawn into the war, some of them killed after Hoover left Spain to return to the United States. The artist depicts herself reading cards, two of them facedown bearing an image of soldiers. Three years after this work was painted, Hoover met Savannah-born poet Conrad Aiken, whom she married in 1937. Her subsequent work included portraits of artist and author friends, among them poet T. S. Eliot. Later in life, she split her time between Cape Cod, Savannah, and Tybee Island, holding exhibitions at Telfair Museums in 1964 and 1975. HD

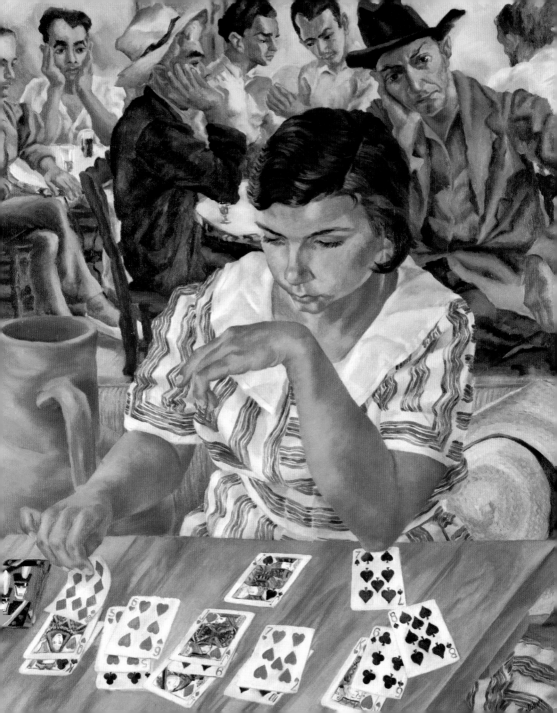

KATJA LOHER
Swiss, born 1979

To Whom Does the Air Belong To?, 2014

Two-channel video, 6:40 min, looped hand-blown glass bubbles, video screen embedded in white
acrylic board, 20 × 15 × 14 in. (50.8 × 38.1 × 35.6 cm)
Museum purchase with funds provided by the Gari Melchers Collectors' Society
2018.8

SWISS ARTIST KATJA LOHER creates video sculptures and environments that blend technology with performance, collaborating with artists of different disciplines, including choreographers, dancers, costume designers, and glassblowers. In her videos, human performers often spell out poems with their bodies, personify creatures from the natural world, or represent forces of nature. Loher's sculptures and installations take the form of projections on weather balloon–size "video planets," as well as smaller domes, glass bubbles, and nests with embedded video screens.

To Whom Does the Air Belong To? appears sleek and futuristic on the outside, contrasting with the nature-focused videos within. Two handblown glass bubbles with inset videos emerge from a clean white acrylic background. In one video, performers costumed as bees participate in the "waggle dance," a movement that bees use to communicate about food sources. In the other bubble, costumed characters represent flower stamens visited by the bees. As the sequence plays out, the "bees" gradually transform, their wings giving way to human arms and their heads becoming those of helmeted human workers. Loher's work speaks to the phenomenon of Colony Collapse Disorder, which resulted in large declines in worker honeybee populations, possibly caused in part by agricultural pesticides. What at first appears to be a window into the natural world is in fact revealed to be a future in which humans may have to assume the work of pollinators if bees disappear. HD

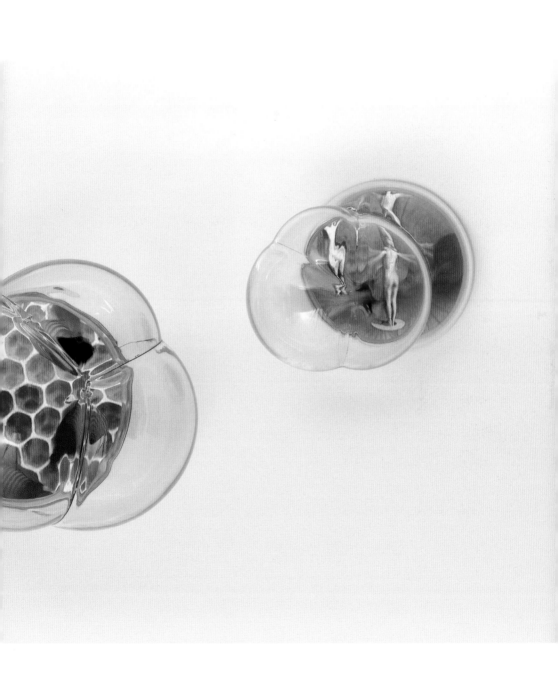

Ethel K. Schwabacher
American, 1903–1984

The Rock, 1961

Oil on canvas, 78 × 65 in. (198.1 × 165.1 cm)

Gift of Christopher C. Schwabacher and Brenda S. Webster

2007.31

Telfair Museums' collection boasts a small yet powerful group of works by female abstract expressionists, whose accomplishments were lauded in their own time but have been historically neglected. Although art historical discussions of abstraction often couch the movement in terms of heroic masculine action and intellect, Ethel K. Schwabacher's work encourages us to consider another facet at play–the deeply personal act of expressing oneself in paint. Her influences ranged widely from Greek mythology to poetry to womanhood and childbirth, and she described her style as "lyric/epic." Her compositions were personal in theme, but also markedly formal; *The Rock* was painted during a period in her long career when she focused on bright colors and jagged, almost disquietingly broad brushstrokes. Schwabacher used the phrase "the place where" to describe the point on the canvas where extremes were unified into a moment of maximum concentration and energy.

Schwabacher began her career in sculpture and transitioned to figurative painting before finally finding inspiration in surrealism and automatism. The latter were introduced to her by her mentor, painter Arshile Gorky. After his suicide in 1948, she continued her lyrical abstractions. Although Schwabacher grew up in a privileged family, her life was punctuated by the deaths of loved ones, psychological breaks, and suicide attempts. She always returned to artmaking as a means of expression, finding comfort in the creative act, which she described as "more like birth where something comes into being than death where disintegration occurs…growth-producing energy rather than an energy that blows things apart." ED

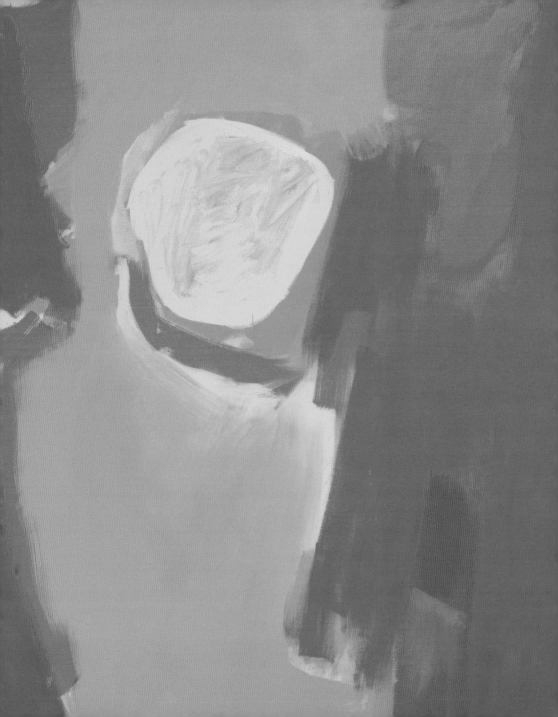

JACOB LAWRENCE
American, 1917–2000

The 1920s...The Migrants Arrive and Cast Their Ballots, 1974

Serigraph on paper, 32 × 24 ¼ in. (81.3 × 61.6 cm)

Gift of Lorillard, a Division of Loew's Theatres, Inc.

1977.19

THE 1920S...THE MIGRANTS ARRIVE AND CAST THEIR BALLOTS calls back to Jacob Lawrence's seminal series of paintings, *The Migration of the Negro* (1940–41). Drawn from his copious research and own lived experience, this body of sixty works addresses the migration of Black families from the rural, poverty-stricken South to the cramped, industrial north in search of more opportunities and less institutionalized racism in the form of Jim Crow laws. Lawrence did not shy away from representing the hardships that migrants faced: this print shows a line of figures standing in a queue, waiting to vote. This fundamental civil right–a freedom that African Americans had greater access to in the north–would have been unthinkable in the South. Lawrence was a pioneering artist and the first African American to be represented by a commercial gallery in New York City. His evocative representations of the struggles that many African Americans faced, often enacted through pared-down forms and collage-like layers, remain a compelling statement on past freedoms denied. And they remind the viewer of the racial injustice that remains in the United States, as well as the work that still needs to be done.

Until Telfair Museums acquired *The 1920s...The Migrants Arrive and Cast Their Ballots* in the 1970s, African American artists were only represented in the museum's collection by vernacular objects shown in the period rooms at the Telfair Academy and Owens-Thomas House & Slave Quarters. This acquisition began a process of rectifying the imbalance in the museum's scope of collecting, which had been singularly focused on white artists since its founding in 1886. Today, the museum continues to work toward building a collection that represents the diversity of Savannah, Georgia, and the United States by acquiring works by artists of color, both past and present. ED

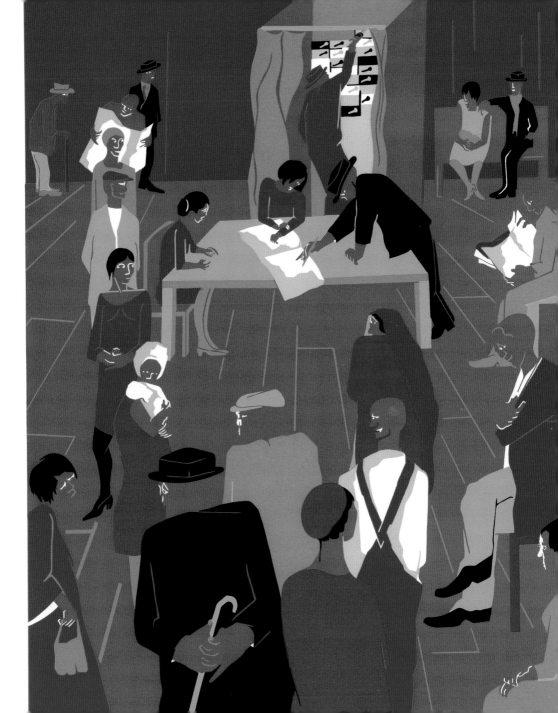

ROBERT GWATHMEY
American, 1903–1988

Marketing, c. 1943

Oil on canvas, 20 ⅝ × 26 ⅜ in. (52.4 × 66.8 cm)
Museum purchase
1944.5

DURING THE 1940S, Robert Gwathmey practiced a social realist art informed by firsthand observation, abstraction, and a concern for social justice. A white artist born in Richmond, Virginia, Gwathmey studied at the Pennsylvania Academy of the Fine Arts and later taught at New York's Cooper Union. On trips to the South to visit family in Virginia and North Carolina, he became increasingly moved by the plight of poor farmers, particularly African American sharecroppers and tenant farmers, addressing this concern in paintings that reveal a corrupt and racist social system.

Like contemporaries Jacob Lawrence and Ben Shahn, Gwathmey painted in an abstracted figurative style utilizing flat areas of color with minimal shading. This style predominates in *Marketing*, which depicts an African American farmer standing on the porch of a rural store, looking into his hand to count change. A hand-painted sign advertises apples, while peeling posters hawk poultry feed, circuses, Coca-Cola, and 666 cold and fever remedy. Behind the farmer, one glimpses an asphalt road and a barren field of red clay. A lone cornstalk and empty tin cans suggest the farmer sees no profit from his labor and lacks funds to buy sustenance. Many African American farmers during this period did not own the land they cultivated. Crop liens held by landowners and merchants often trapped sharecroppers in a life of debt and bondage, and even New Deal marketing agreements and policies designed to help farmers spurred evictions of tenants from the land they worked. Gwathmey's ironic title, *Marketing*, contrasts this struggle for survival against the tattered promise of the American Dream—its products and leisure well out of the sharecropper's reach. HD

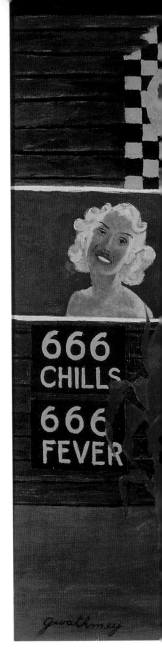

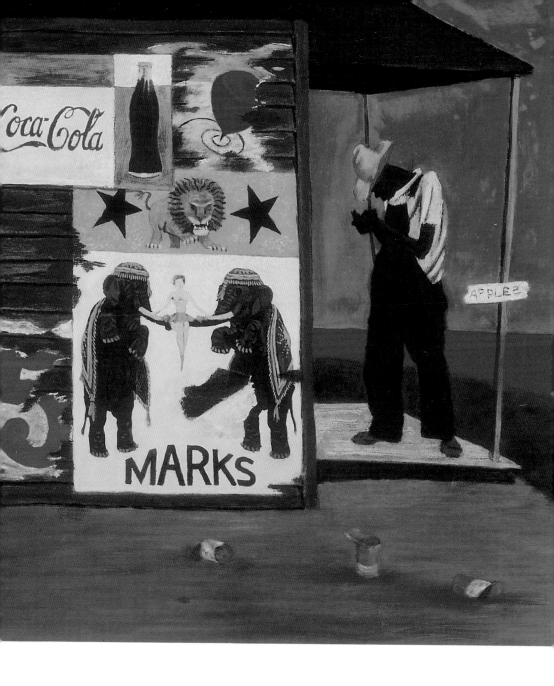

HENRY OSSAWA TANNER
American, 1859–1937

Untitled, 1880
Oil on canvas, 15 1/8 × 25 3/16 in. (38.4 × 64 cm)
Museum purchase with funds from the bequest of Shirley Carson
1998.29

HENRY OSSAWA TANNER, BORN in Pittsburgh on the eve of the Civil War, was the son of a former enslaved woman who escaped through the Underground Railroad and a bishop in the African Methodist Episcopal Church. After relocating to Philadelphia in 1868, Tanner studied under the American realist Thomas Eakins at the Pennsylvania Academy of the Fine Arts before moving to Paris and becoming a pupil of the academic painter Jean-Joseph Benjamin-Constant at the Académie Julian. This relocation was motivated by more than a pursuit of French artistic training; the artist, who found in Paris a respite from the particular kinds of racial discrimination experienced in the United States, explained: "I could not fight prejudice and paint at the same time."

Although Tanner was pressured to produce genre scenes featuring dignified Black people—by Booker T. Washington, among others—he made works that appealed to the main-stream contemporary art market, most notably religious and Orientalist paintings. Orientalism purported to accurately represent what we now call the Middle East; this idea has since been debunked by contemporary scholars who have argued that these works heavily exoticized and romanti-cized the "East." Tanner was regularly awarded medals and museums started to collect his artwork during his lifetime. This marine painting features a group of children, adults, and pets frolicking on the beach. The cloudy sky, crashing waves, and silhouettes of ships are rendered with a soft, almost hazy touch that underscores the artist's realist yet poetic vision—a painterly treatment characteristic of much of his oeuvre. ASB

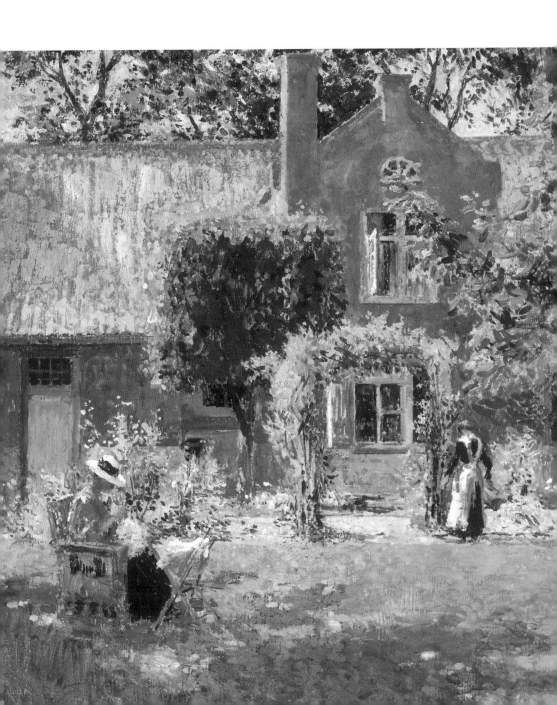

GARI MELCHERS
American, 1860–1932

The Unpretentious Garden, *c.* 1903–15

Oil on canvas, 33 ⅝ × 40 ½ in. (85.4 × 102.9 cm)

Museum purchase with funds provided by the Button Gwinnett Autograph Fund

1916.5

A PERENNIAL FAVORITE AMONG MUSEUM visitors thanks to its cheerful sunlight and inviting subject, *The Unpretentious Garden* is also symbolically important to Telfair Museums. It is the only work by Gari Melchers—the renowned artist who served as the museum's fine arts adviser from 1906 to 1916 (and unofficially through the 1920s)—acquired by the museum during his lifetime. Melchers used his prescient eye and well-placed connections in the art world to negotiate the acquisition of some of Telfair's most important works (pp. 6–7, 14–15, 20–21, and 76–77). Yet the museum owned no works by Melchers himself, even as the artist continued to garner awards and acclaim for his paintings. The museum's trustees rectified this in 1916, voting to honor Melchers's service and legacy by purchasing *The Unpretentious Garden* for its permanent collection. Melchers, keen to avoid even the appearance of impropriety, was reluctant to sell a work to the museum he had advised. In a letter to Melchers, Telfair's board president stated: "I note the reluctance with which you sold us this picture, and I repeat my oral assurances to you that I very much appreciate your yielding to our persistence."

The subject of the painting is the artist's wife, Corinne Lawton Mackall Melchers, whose uncle was the president of Telfair's board and who thus served as the link between her husband and the museum. Corinne is shown seated outside the couple's home in the Dutch fishing village of Egmond aan den Hoef while a servant tends to the garden nearby. Melchers worked in the Netherlands for more than thirty years and produced many of his best-known works there. CAM

Sam Gilliam
American, born 1933

Inlana, 1969–71
Oil and acrylic on canvas, 45 × 70 × 2 in. (114.3 × 177.8 × 5.1 cm)
Gift of Dr. and Mrs. Jerome W. Canter
2006.42

Acid greens, hot pinks, and teal blues are just a few of the vibrant colors that saturate the canvas of Sam Gilliam's *Inlana*. The stained canvas projects from the wall through Gilliam's distinctive use of beveled-edge stretcher bars. Telfair Museums holds three works by Gilliam in its collection, each piece revealing another aspect of the artist's relentless innovation. Gilliam was initially acknowledged by the art world for his draped, folded, and soaked canvases freed from their stretcher supports, which were inspired by the sight of women hanging laundry on a clothesline. These works were first exhibited in 1969 at the Corcoran Gallery of Art in Washington, DC.

An artist known for experimentation, Gilliam often works in series and devises certain structures and systems of order to work within. It has been argued that his most significant contribution to art history has been the erasure of easy definitions delineating painting and sculpture. In creating objects that act as both art forms, Gilliam removes the need for such boundaries. After his arrival in Washington, DC, in 1961 and his association with artists such as Morris Louis and Kenneth Noland, Gilliam was heralded as a second-generation member of the Washington Color School and the only African American artist associated it. However, his work went beyond their investigations into abstraction and questioned the structures of painting itself. His artistic practice continues to stimulate viewers who experience the electric pull of his works–provoked through his use of texture and color, and his willingness to experiment. ED

William O. Golding
American, 1874–1943

Tug William F. McCauley, Atlantic Towing Company, Savannah, Georgia, 1934

Pencil and crayon on paper, 9 × 12 in. (22.9 × 30.5 cm)

Museum purchase

2009.23

ONE OF THE MOST POIGNANT AND underappreciated stories in American art belongs to the African American seaman and artist William O. Golding. Golding condensed a half-century of maritime experience into more than one hundred drawings, produced largely from a hospital bed in Savannah during the 1930s. The son of a Reconstruction lawmaker from Liberty County, Georgia, Golding was kidnapped from the Savannah waterfront, tricked into service aboard a Canadian vessel at the age of eight. He spent twenty-two years serving on sailships and steamships before seeing his home again. In the 1930s, Golding was an intermittent patient at the United States Marine Hospital in Savannah, where he was treated for chronic bronchitis. Nicknamed "Deep Sea," Golding swapped stories with fellow patients and rendered his experiences in expressive pencil and crayon drawings. His works bear a unique style brimming with visual invention and an ever-present sun in the form of a compass rose.

Golding drew numerous vessels he claimed to have served on or seen, from whalers in the Arctic to the steam yachts of New York's elite. Several works depict the Savannah waterfront and city landmarks, including this image of the tugboat *William F. McCauley*. Built in 1894, the *McCauley* was based in Savannah and commissioned by the US Navy during World War I. Encouraged by local artist Margaret Stiles, Golding also depicted international ports he had visited during his decades at sea, which may have included naval service in the Philippines during the Spanish-American War. His drawings of ports in the Philippines, China, Vietnam, and Indonesia bear witness to the experiences of a merchant seaman at the turn of the century. HD

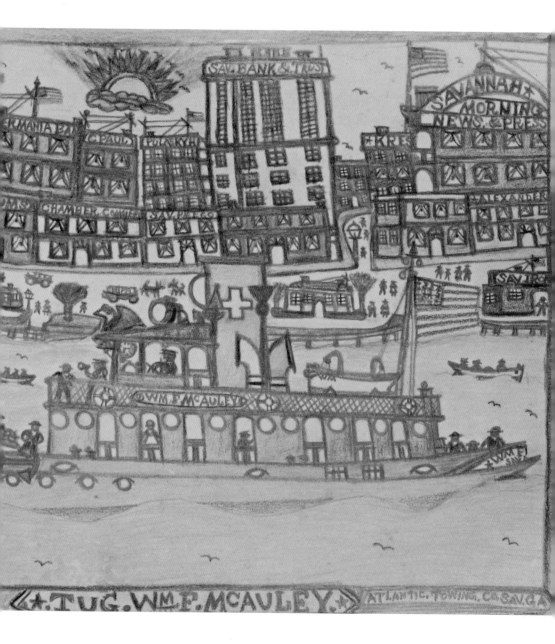

TUG WILLIAM F. MCCAULEY, ATLANTIC TOWING COMPANY, SAVANNAH, GEORGIA | **41**

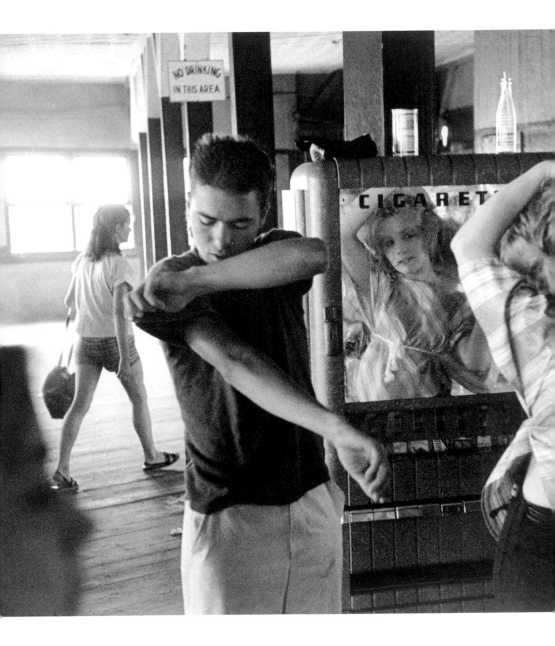

BRUCE DAVIDSON
American, born 1933

Untitled, Brooklyn Gang series, 1959

Mid-vintage gelatin silver print, 16 × 20 in. (40.6 × 50.8 cm)
Gift of an anonymous donor
2018.16.18

IN THE SPRING OF 1959, at the age of twenty-five, Bruce Davidson still looked young enough to hang out with the "The Jokers," a group of teenagers from Brooklyn. After the self-proclaimed gang was featured in a newspaper article detailing their misdeeds, Davidson felt a keen desire to meet them. He wrote that he "found [himself] involved with a group of unpredictable youths who were mostly indifferent to me. In time they allowed me to witness their fear, depression and anger. I soon realized that I, too, was feeling some of their pain. In staying close to them, I uncovered my own feelings of failure, frustration and rage." Davidson is known for his empathetic photographs, born of genuine interest in his subjects and a desire to remain with them for a long period of time. Known as a street photographer, he has a knack of finding subjects to explore and inhabit, leading to some of the most engaging photographic series of the twentieth century.

This iconic image shows Cathy, the "Brigitte Bardot" of the group, prinking in front of a mirror. She stands on a cigarette machine in a bathhouse on the Coney Island Beach while another member of the gang, Artie Jean Marino, rolls his sleeve with careful precision. Davidson caught them living, often unawares, and young, but looking to make an impression on the world. But sometimes his images obscured the full narrative. While their lives appeared carefree, the teens often acted out because of their unstable homelives, poverty, or lack of education. This photograph is one of 348 that were gifted to Telfair Museums in 2018 and helped solidify the strength of the museum's growing photography collection. ED

Helen Levitt
American, 1913–2009

New York, c. 1940
Gelatin silver print, 11 ⅛ × 7 ½ in. (28.1 × 19.1 cm)
Gift of Mrs. Robert O. Levitt
2002.3.1

Born and raised in New York City, Helen Levitt studied photography at the Art Students League. She gained further training when she assisted the famous documentarian Walker Evans from 1938 to 1939 as he recorded the bustling underground world of the New York subway system. Like many of her contemporaries—who were inspired by the French photographer Henri Cartier-Bresson and his celebration of the "the decisive moment"—Levitt photographed candid street scenes. She utilized a handheld 35 mm camera with a right-angle viewfinder to capture her subjects unaware and preserve the spontaneity of the moment.

Levitt's oeuvre consists almost exclusively of urban landscapes and the humans and animals populating them. When turning her lens to the children of the working-class inner city in the 1940s, the street often appears as an exhilarating (if occasionally dangerous) playground. In this image, the viewer encounters a busy New York sidewalk with individuals absorbed in their daily activities, unmindful of the children in the foreground. A child bends forward to grab a piece of shattered glass on the road as the others look on and adults pass by. At the center, two children grip a large, empty frame, through which emerges a child on a bicycle. This serendipitous double framing—Levitt's photograph framing the scene and the wooden frame outlining the boy on the bicycle—creates a *mise en abyme*, an image within an image, or a poetic mirroring effect. Looking back at the uniqueness of her work and the particular period which it documents, Levitt explained: "Children used to be outside. Now, the streets are empty. People are indoors looking at the television or something." ASB

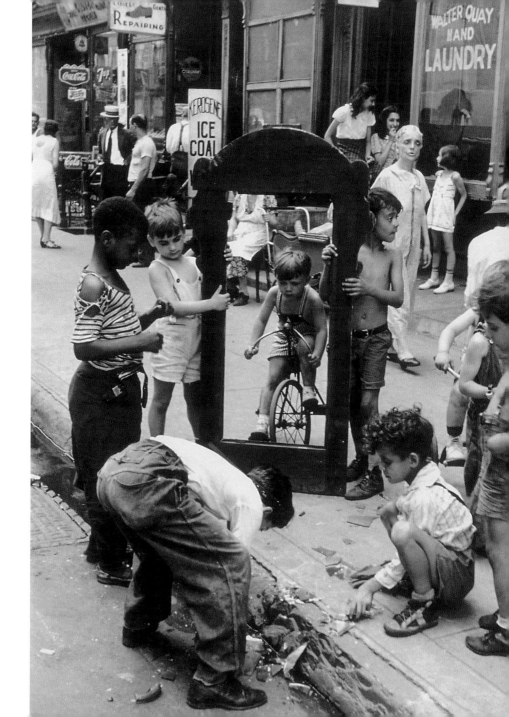

FREDERICK C. BALDWIN
American, born 1929

Benjamin Van Clark Leading a March, Bull Street, 1963

Gelatin silver print, 13 ⅛₆ × 8 ⅜ in. (33.2 × 21.9 cm)

Museum purchase

2009.3.23

THE 1960S CIVIL RIGHTS MOVEMENT in the United States spawned indelible images, as photographers Black and white chronicled brave and hopeful protests along with the brutality with which they were often met. This photograph from a series taken in Savannah in 1963 and 1964 sums up the determination and youthful leadership that effected social change in the city. For photographer Frederick C. Baldwin, this was a pivotal period in a long and colorful career.

Baldwin was born in Switzerland to an American diplomat father and a mother with family in Savannah. After service in the Korean War and studies at Columbia University, he sought a career in photojournalism, making a name for himself with Arctic adventures in which he photographed polar bears underwater. Returning to Savannah in the early 1960s, he embarked on a very different journey after discovering the city's burgeoning civil rights efforts. Baldwin offered his services to the Southern Christian Leadership Conference and the Chatham County Crusade for Voters, documenting voter registration drives and daily marches in opposition to segregation. A significant leader in Savannah's movement, Benjamin Van Clark began participating in protests as a high school student. Taken in the summer of 1963, this image shows the nineteen-year-old Clark leading a group from City Hall down Bull Street to Wright Square, where fellow leader Hosea Williams addressed demonstrators. Clark's face is resolute as he advances through the midday heat, a man behind him chanting and holding a flag in front of another with a bandaged cheek. More than documentation, this powerful image connects past and present civil rights struggles as marchers today follow the same route. HD

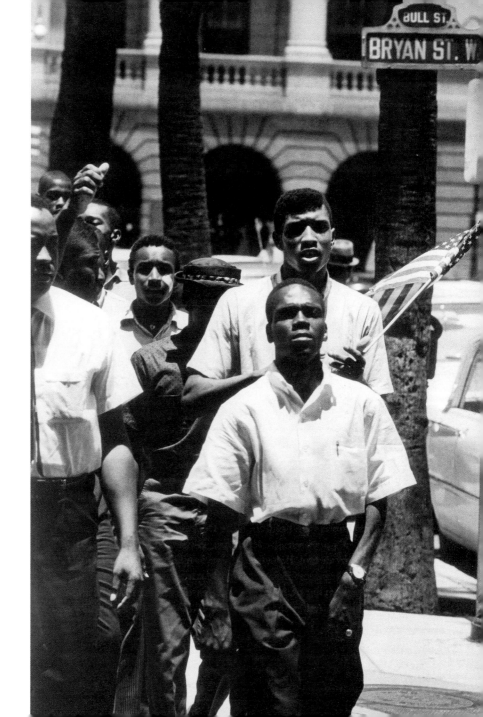

SARAH JONES
American, 1756–1804

Sampler of Ten Commandments, Lord's Prayer and Apostles'
Creed, 1763
Linen ground fabric with silk embroidery floss, 13 ¾ × 15 ¼ in. (34.9 × 38.7 cm)
Gift of Mrs. Hubert Bond Owens
1971.4

TO THE FRUSTRATION OF contemporary scholars, women in histori-
cal records are often positioned as accessories to men. Descriptions
identify women as the "wife of" or "daughter of" important men,
without any insight into who these women were or how they affect-
ed history. Likewise, most of the decorative arts in museum collec-
tions are identified as having belonged to men, but they were more
likely the possessions and selections of women, who often ran the
household. Similarly, while the education of prominent men is doc-
umented, from the universities they attended to the mentors who
nourished their growth, the record on female education is scant.
The historical record does show that most girls were educated in
domestic arts in addition to basic academic subjects, and almost all
such educations included needlework.

Sarah Jones created this sampler, the earliest-known example
from Georgia, to showcase her achievements when she was seven
years old. Like many samplers of the period, this one displays her
stitches via the religious texts that were part of most children's edu-
cation. While directly related to many prominent men, Jones was a
significant person in her own right. She bore ten children and sur-
vived a war while raising them without local male support, which
was absent during the chaotic Revolutionary War years. After the
war, it was Jones who petitioned the Georgia Assembly to remedy
her husband's problematic situation, caused by switching sides
during the Revolution. He eventually regained political prominence
and served as mayor of Savannah. Sarah moved to Connecticut
where several of her children were educated, including her daugh-
ter Mary Jones Glen, whose education, like her mother's, included
needlework. SBM

The
Commandments

I

Adore no other Gods but only me

II

Worship not god by any thing you see

III

Reverence jehovahs name swear not in vain

IIII

Let sabbaths be a feast for men and beast

V

honour thy parents to prolong thy days

Our Father which art in heaven hallowed be thy name thy kingdom come thy will be done in earth as it is in heaven give us this day our daily bread and forgive us our trespasses as we forgive them that trespass against us and lead us not into temptation But deliver us from Eviel For thine is the kingdom the power and the glory for ever and ever amen

Ten
in verse

VI

thou shalt not kill nor murdering

VII

Adultery thun ur chastity delight

VIII

thou shalt not steal nor take anothers right

IX

bearing witness never tell a lie

X

what is not thine what may others dainty

I believe in God the Father almighty maker of heaven and Earth and in Jesus Christ his only son our Lord who was conceived by the Holy Ghost Who was born of the Virgin Mary Suffered under Pontius Pilate was crucified dead and buried he descended into hell the third Day he rose again from the dead he ascended into heaven and sitteth on the right hand of God the Father Almighty from thence he shall come to judge the quick and the dead I believe in the Holy Ghost

Sarah Jones aged 7 years

DAVID DRAKE
American, *c.* 1801–1870s

Dave Jar, 1861

Alkaline glazed stoneware, 14 × 21 in. (35.6 × 53.3 cm)

Museum purchase with funds provided by the Gari Melchers Collectors' Society

2018.7

SLAVERY IS A CONDITION not only of oppression and subjugation, but also of anonymity. Most enslaved people disappear into history. Those who do not disappear may survive as numbers in the account records of their enslavers. Sometimes, historians are lucky enough to find a name. In a few cases, scholars learn more and these shadows from history become people, with real lives and loved ones who can be imagined. In the United States, this rare evidence usually comes in the form of narratives (collected decades after emancipation by the Works Progress Administration) or from the autobiography of a self-liberated freedom seeker. In the instance of the man who became known as Dave the Potter, most of our knowledge comes in the form of a ceramic jar. A few words can communicate a great deal about an individual—such was the case with Dave's pottery. Dave was an enslaved potter in Edgefield, South Carolina. Like many enslaved potters, he created thousands of vessels in his life. Unlike any other known, he signed hundreds of them and inscribed dozens with poems and verses. Dave likely learned to read and write while working at the newspaper operated by his enslaver's family.

This particular jar is notable for its large, distinctive signature (about two inches high) and the date of production. The inscription reads, "LM June 18 1861 Dave." This jar is significant because it was created, signed, and dated during the Civil War, a time of great hope and trepidation for enslaved people all over the country. Even during these unsettled times, Dave proudly inscribed his name. David Drake is the full name he chose after the Civil War ended. SBM

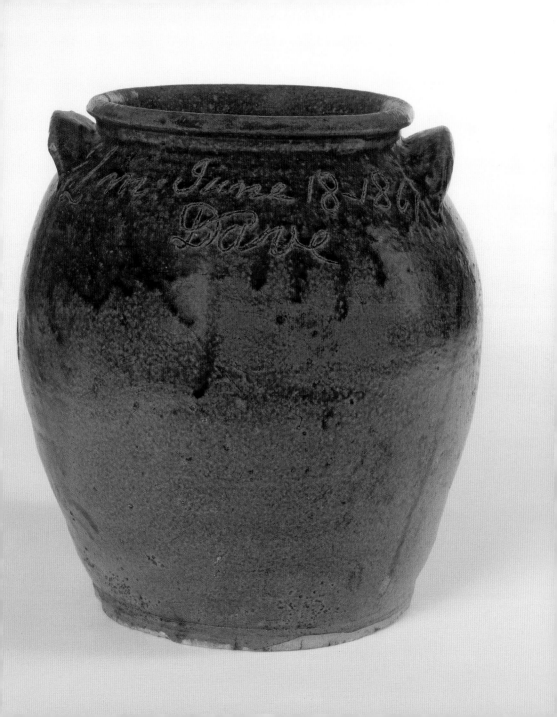

CARRIE MAE WEEMS
American, born 1953

Untitled, 1994
Gelatin silver print, 24 × 20 in. (61 × 50.8 cm)
Gift of Zoë and Joel Dictrow
2012.12.2

CARRIE MAE WEEMS USED her domestic space and body as the subject for a groundbreaking group of photographs, *The Kitchen Table Series*. This choice was motivated by practical considerations: Weems worked as an assistant professor at Hampshire College and when she had time to dedicate to her art, she relied on her own availability and willingness to pose for her camera to represent her vision fully. The series explores the universality of relationships and patterns of behavior that occur in domestic spaces, of which the kitchen table is an essential component. Nourishment–both for the body and soul– occur at the kitchen table. Weems also sees in this space an arena specifically for women of color to become part of the conversation and invoke their stories. On a purely aesthetic level, the beauty of the image is focused on its softness and by the single, luminary lamp overhead. That softness is undercut by a possible tension arising from the lack of communication and body language between the two characters. While the man remains seated at the table, his atten- tion fixed on an open newspaper, a half-full glass of water at his elbow, the woman is standing, her gaping robe revealing lingerie. Her downward gaze fixes on the back of the man's head. The viewer, placed at the far end of the table, is unsure if the man is unaware or unwilling to notice her.

This photograph came to Telfair Museums as part of a Printed Matter portfolio, and while it is not one of the original twenty photo- graphs and text panels in *The Kitchen Table Series*, its subject matter ties the work to the series's legacy. Weems considers this series piv- otal in her career and in the history of art. The series argues that the home can act as a place for women to be complex beings; it can also be a space for women of color to participate in the narrative. ED

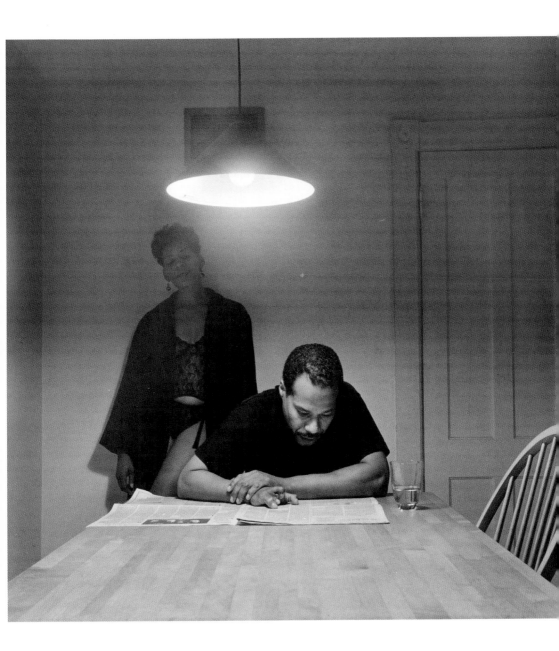

NICKOLAS MURAY
American, 1892–1965

Frida in Pink and Green Blouse, Coyoacán,
1938 (printed 2005)
Color carbon pigment print on paper, 13 ⅞ × 9 ⁹⁄₁₆ in. (35.2 × 24.3 cm)
Gift of Mrs. Robert O. Levitt
2008.7

BY THE TIME NICKOLAS MURAY met Frida Kahlo in 1931, the Hungarian photographer had gained notoriety as a celebrity portraitist. Muray initially worked for magazines such as *Harper's Bazaar* and *Vanity Fair*, capturing the faces of New York's high society and American icons, including Marilyn Monroe, Frank Sinatra, and Elizabeth Taylor. He immigrated to the United States from Germany before World War I after developing an expertise in photoengraving and color photography. While living in New York, Muray distinguished himself by mastering the tri-color carbro printing process, an arduous technique rarely used today but prized in the 1950s for yielding remarkably vibrant color photographs.

Throughout their twelve-year relationship—which became romantic for a period—Muray photographed Kahlo countless times, creating a rich archive of the Mexican artist's life and work. Born in 1907 and beginning to paint in earnest in 1925 at the urging of her husband, the Mexican muralist Diego Rivera (see figure), Kahlo created art that blended realism and fantasy and has since been associated with surrealism and Mexican modernism. She produced a significant number of self-portraits in which she donned colorful Tehuena garb, Mexican indigenous clothing, and it is argued that she deliberately used these portraits to craft an artistic persona. The originality of her work and the aesthetic allure of this persona—further bolstered and promoted by Muray's photographs—helped catapult the artist to posthumous renown. In this image, Kahlo mysteriously gazes off-frame, allowing the viewer to focus on her carefully crafted sartorial symphony of colors, flowers, fabrics, and patterns. ASB

BELOW:
Nickolas Muray (American, 1892–1965)
Frida and Diego with Hat, 19[...]
Gelatin silver print, 12 ⅜ × 12 ½ in. (31.4 × 31.8 cm)
Gift of Mimi Muray Levitt, 2018.10

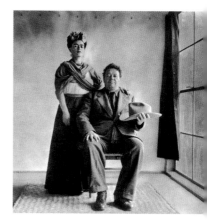

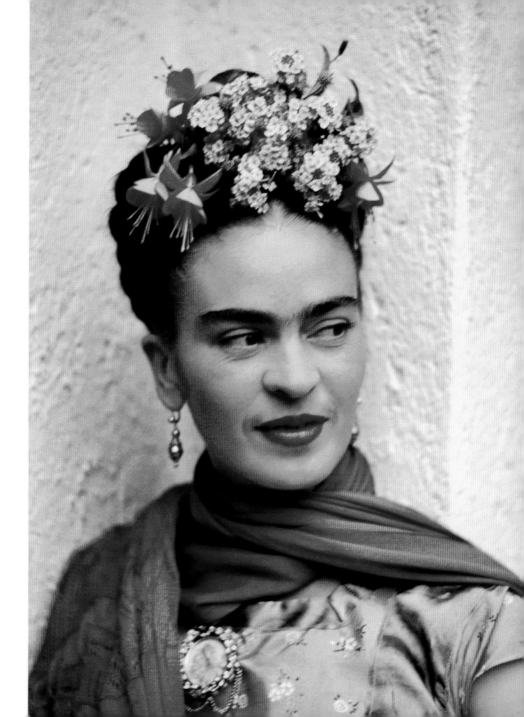

UNKNOWN

Library Table, undated

Walnut, 29 ½ × 35 ½ × 68 ¼ in. (74.9 × 90.2 × 173.4 cm)
Bequest of Mary Telfair
1875.52

DECORATIVE ARTS AND HISTORIC sites offer museums the opportunity to tell stories of the past with tangible objects— to see the actual places where events occurred, the chairs the actors sat in. This desk offers an intimate view into William Brown Hodgson's nineteenth-century study in the Telfair House. He stands at this very desk in a portrait painted for, and still displayed in, the Georgia Historical Society's Hodgson Hall in Savannah (see figure).

Mary Telfair's will called for her family home to become a "Library and Academy of Arts and Sciences," a place for learning and teaching in the Western academic tradition. Few people embody that tradition better than her brother-in-law William Brown Hodgson, who almost certainly influenced her decision to establish the Telfair Academy, now part of Telfair Museums, in her will. Over his sixteen-year diplomatic career, Hodgson visited cities and countries all over the world, including Algiers, Constantinople, Egypt, Panama, and Tunis. He studied the languages and customs of many of the people he encountered during that time. As a result of his travel and studies, Hodgson learned thirteen languages, including Arabic, Berber, French, Hebrew, Persian, Sanskrit, Spanish, and Turkish. Hodgson ultimately published works on ethnology, linguistics, and geology and became a curator of the Georgia Historical Society, as well as a member of the American Philosophical Society and the American Oriental Society.

While Hodgson's desk serves as a reminder of his intellectual prowess, his achievements must be considered in the context of his participation in and profits from the Southern slave system, which provided him with the financial resources necessary to pursue his academic interests. SBM

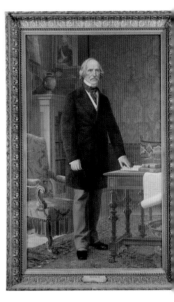

ABOVE:
Carl Brandt
(American, 1851–1905)
Portrait of William Brown Hodgson, 1875
Oil on canvas, 98 × 64 in.
(249 × 165 cm)
Courtesy of the Georgia Historical Society
A-1361-084.

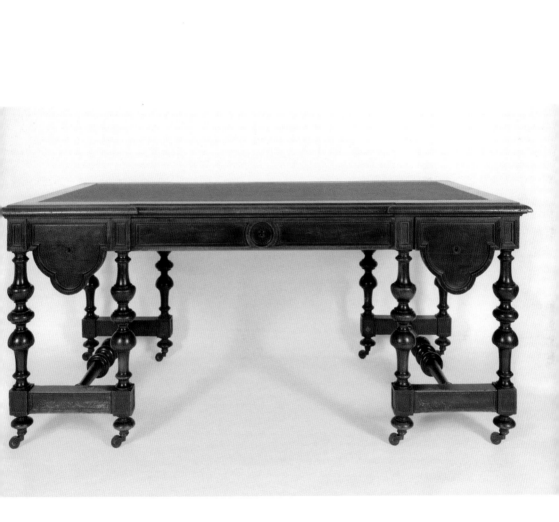

JACK LEIGH
American, 1948–2004

Midnight, Bonaventure Cemetery, 1993 (printed 2000)

Gelatin silver print, 17 ⅞ × 12 ¼ in. (45.4 × 31.1 cm)
Gift of the Artist
2002.2.1

ONE OF SAVANNAH'S MOST RESPECTED photographers, Jack Leigh is known for photo essays documenting his native South. He studied at the University of Georgia, discovering his medium in a documentary photography course, and he later learned from influential photographers George A. Tice and Eva Rubinstein. After traveling in Europe and living in Virginia, Leigh returned to Savannah in the 1970s, where he found inspiration recording the lives of oystermen and other Southerners rarely seen in photographs.

In 1993 author John Berendt recommended Leigh to Random House to create the cover image for Berendt's novel *Midnight in the Garden of Good and Evil*. Leigh worked in Savannah's historic Bonaventure Cemetery for two days, obtaining permission to stay after hours. He discovered Sylvia Shaw Judson's *Bird Girl* as the light was ebbing, and shot the bronze sculpture using a technique known as lens compression in order to make the sculpture appear monumental. Afterward, Leigh manipulated the image in the darkroom, using filters and the "dodging" method to lighten the area around *Bird Girl*. This highly constructed image attests to Leigh's traditional photographic craftsmanship. It was the sole image he submitted to Random House for the cover of Berendt's book, which became a smash best seller. Leigh's iconic image made him internationally famous, enabling him to open the Jack Leigh Gallery. The book's success also spawned a movie adaptation, after which Leigh became involved in a legal battle over promotional images that were similar to his *Midnight* photograph. Leigh's final photographic series documented the construction of Telfair Museums' Jepson Center. He died from cancer in 2004 at age fifty-five and is buried at Bonaventure Cemetery beside his parents. HD

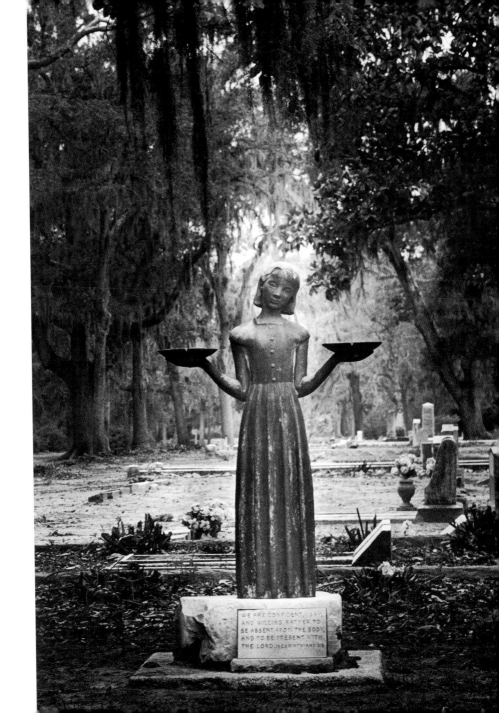

WE ARE CONFIDENT, I SAY,
AND WILLING RATHER TO
BE ABSENT FROM THE BODY,
AND TO BE PRESENT WITH
THE LORD. II CORINTHIANS 5:8

MICKALENE THOMAS
American, born 1971

Sleep: Deux Femmes Noires, 2013

Woodblock on paper, silkscreen on paper, and photographic elements,
32 ⅛ × 74 ⅞ in. (81.6 × 190.2 cm)
Museum purchase
2015.6

MICKALENE THOMAS BOLDLY appropriates art historical imagery–especially from traditions that have ignored the voices of individuals of color and the queer community. Composed of photographic, woodblock, and silkscreen elements, this large-scale print directly references Gustave Courbet's highly sensual painting *Le Sommeil* (*The Sleepers*, 1866). In the nineteenth century, Courbet's painting shocked viewers with its brazen depiction of two white women entwined in a perceived act of lesbianism. As a queer artist of color interested in issues of femininity, Thomas updates Courbet's theme as a normalization of homosexual love, thus returning power and sexual agency to her subjects.

This print originated from a small photographic collage that was also the basis for Thomas's prominent 2011 painting of the same subject. She often reworks the same subject matter in various mediums to fully realize her initial vision. Thomas reimagined the scene with two Black women embracing on a pile of patterned textiles, set in a landscape composed from photographs of her trip to Africa. The collage process is extremely pronounced in *Sleep: Deux Femmes Noires*, as evidenced by the electric-pink zigzags that fracture the surface. The collection of disparate photographs, prints, colors, and textures creates a lush environment that surrounds the female bodies. Because of the intimacy of their pose, the openness of surrounding landscape takes on a dreamlike quality. ED

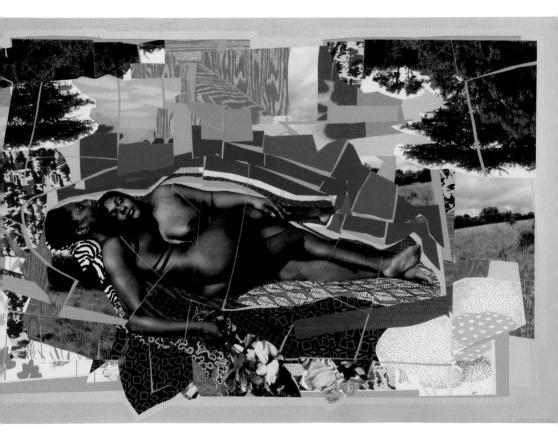

NICK CAVE
American, born 1959

Soundsuit, 2012

Mixed media sculptural suit including beaded and sequined garments, fabric, and metal with a display
mannequin armature, 109 ¾ × 24 × 12 in. (278.8 × 61 × 30.5 cm)

Museum purchase with funds provided by Mr. and Mrs. Robert M. Levy, Susan Willetts and Alan K. Pritz,
Cathy and Philip Solomons, Diane and Ed Schmults, Pamela L. and Peter S. Voss, Jan and Lawrence Dorman,
Friends of African American Arts, Dr. William Goldiner, Dr. David M. Hillenbrand, Rosaleen Roxburgh, Ted
and Linda Ruby, Marti and Austin Sullivan, Mr. and Mrs. Robert Young, and the Jack W. Lindsay Acquisition
Endowment Fund

2017.6.a–b

VIEWERS CONFRONTED WITH A "soundsuit" by Chicago-based artist
Nick Cave come face-to-face with a densely decorated garment cov-
ered in embroidered flowers and colorful sequins. The embellished
surface of the work calls attention to the wearer while still provid-
ing protection and coverage against preconceived judgment. The
impetus to create the first soundsuit was Cave's despondency at his
place as an African American man in the United States, especially
in the fraught year after the Rodney King beating and Los Angeles
riots. He sought to create a coat of armor to protect himself, a wear-
able construction that concealed race, gender, and class. Often
made from found materials, Cave's soundsuits breathe new life and
purpose into discarded items. The suits offer the wearer a chance to
explore their identity while being sheltered from societal prejudice.
An artist of many interests and talents, Cave incorporates dance,
fashion, and performance into his visual practice. The soundsuits
are made to the scale of his body and are meant to be worn in a per-
formance, but can also exist as independent sculptural objects. ED

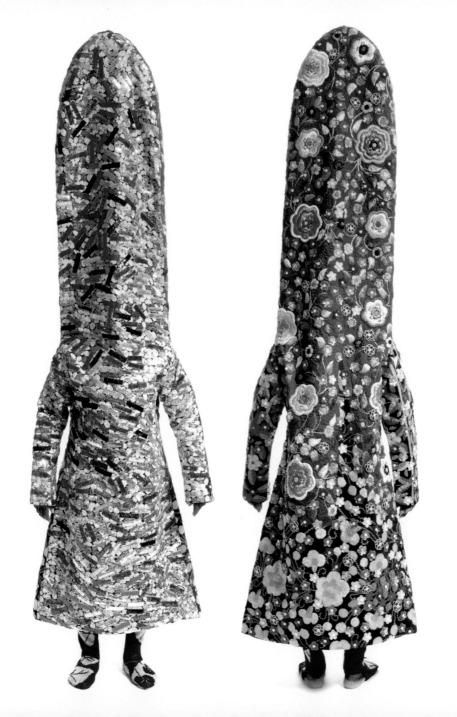

THERESA BERNSTEIN
American, 1890–2002

Fair on Hawthorne Inn Lawn, 1918

Oil on board, 16 × 20 in. (40.6 × 50.8 cm)

Museum purchase with funds provided by the Gari Melchers Collectors' Society

2019.33

THERESA BERNSTEIN WAS TRAINED at the Philadelphia School of Design for Women and the Art Students League in New York under the tutelage of artists such as William Merritt Chase, a proponent of American impressionism. However, her art more closely resembles the works of the Ashcan School, a group of American realist artists who challenged the impressionist and academic traditions. Their work often reflected the grittiness and vitality of working-class and immigrant populations and the urban landscapes they occupied. While not officially part of the all-male group, Bernstein was aligned with the Ashcan painters in her subjects, interests, and aesthetics.

Bernstein created *Fair on Hawthorne Inn Lawn* while she summered in the fishing village of Gloucester, Massachusetts. Describing the piece in a letter, she explained: "I painted this subject several times just before the end of WWI. The affair was for the benefit of the wounded veterans." The gestural, almost rough brushstrokes and bold coloring displayed here may partly explain why twentieth-century critics characterized Bernstein as a "woman who paints like a man." She continued to produce art into the twenty-first century, and her work experienced a revival during the second-wave feminism of the 1970s, a time when the discipline of art history sought to trouble and expand its male-dominated canon. This painting fits particularly well in Telfair's collection—which includes a number of American impressionist and Ashcan School works—and is emblematic of the museum's concerted mission in recent years to introduce its visitors to historically underrepresented artistic talents. ASB

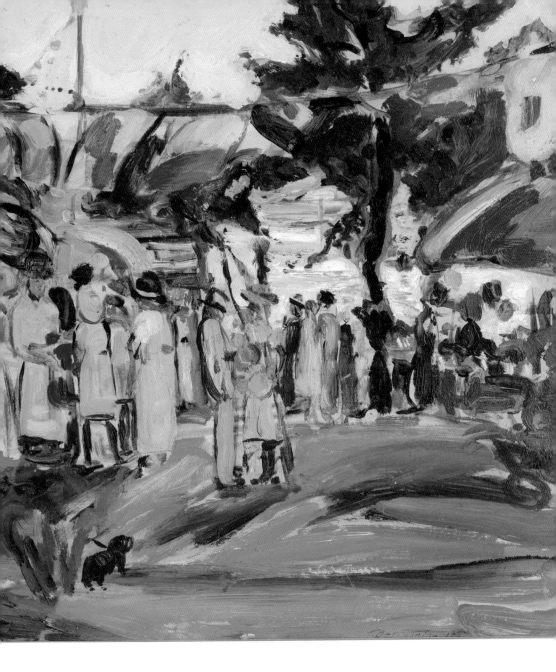

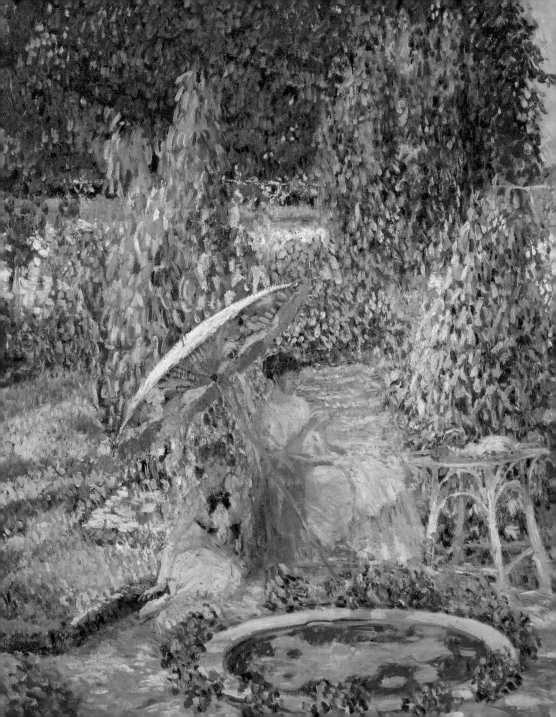

FREDERICK CARL FRIESEKE
American, 1874–1939

The Garden Umbrella, by 1910

Oil on canvas, 32 ⁵⁄₁₆ × 32 ⁵⁄₁₆ in. (82.1 × 82.1 cm)

Bequest of Mrs. Elizabeth Millar Bullard

1942.7

LIKE MANY ASPIRING AMERICAN ARTISTS, Frederick Carl Frieseke traveled to Paris in the late nineteenth century to study and paint. Unlike most of his contemporaries, he took up long-term residency in France (for a time renting the house next door to Claude Monet in Giverny) and remained in the country through World War I. Frieseke noted, "I couldn't stand leaving Paris after the years I've lived here. Seemed like running away." For several months during the war, he served in the Red Cross ambulance corps just outside Paris, as reported in a 1914 *New York Times* article with the headline "Artists in Ambulance Corps: Frieseke and Other Americans Serving as Orderlies."

Frieseke was an influential member of the second wave of American impressionists, artists who took up the original French impressionists' fascination with sunlight and shadow; bright, unblended colors; and a commitment to painting outdoors, *en plein air*. He would become the leader of a set of these artists known as the Giverny Group. *The Garden Umbrella* demonstrates the subject and style for which Frieseke and his Giverny Group colleagues were best known: a female figure shown outdoors amid a riotously colorful garden. The canvas is distinguished by broken brushwork, vibrant color, and the dappled sunlight that sparkles across the landscape. The subject of this painting is Frieseke's wife, Sadie, most likely accompanied by her niece, Aileen O'Bryan, who spent the summer of 1910 with them in Giverny. CAM

Thomas Cook
American, active 1820–37

Dining Table, 1856

Mahogany, oak, and pine; overall height: 28 ½ in. (72.4 cm); diameter without leaves: 52 ½ in. (133.4 cm)

Bequest of Mary Telfair

1875.57.a–i

THERE ARE FEW MOMENTS in life comparable to those spent at a dining table with friends and family enjoying food, wine, and conversation. The Telfair family had many such evenings around this table, which Margaret (sister of Telfair Museums' founder Mary Telfair) purchased for the Telfair House (now known as the Telfair Academy) from Philadelphia furniture maker Thomas Cook in 1856. The unusual round design was shockingly egalitarian for a formal dining table in nineteenth-century Savannah. However, the cast of characters seated around this table were not. The Telfairs were part of the exclusive Coastal Aristocracy, a small group of families who won their wealth and status through the enslavement of other people in the South, while paying seasonal visits to drawing rooms in the north and in Europe. It was during one such visit to Philadelphia that Margaret commissioned the table before continuing her trip to New York. The table was received by Mary, who wrote: "Just as I had dispatched my last epistle my dear Margaret—the above named Franklin bowed himself into our presence with Bill of Lading…in one hand, and a receipt in the other—I seated his Honor, gave him this sheet of paper, and dispatch(ed) his autograph, paid him your money, talked of Armoures [sic] to him and wished him good morning…" Over this personal note appears the transaction:

Recd Oct 25th 1856 of Miss Telfair
One hundred Dollars in full for circular
Dining Table – Thos. Cook
$100 Jno G. Franklin

One hundred dollars was a considerable amount of money to spend on a dining table in 1856. The extravagant cost could perhaps be attributed to the clever design with two sets of interchangeable leaves. SBM

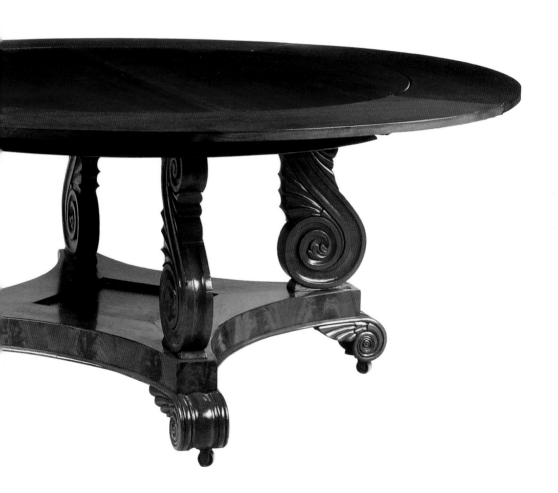

VERNON EDWARDS
American, 1940–1999

Harriet Tubman, 1982

Mahogany and paint, 10 ¹³⁄₁₆ × 3 ⅜ × 2 ⅜ in. (27.5 × 8.6 × 6 cm)

Museum purchase

1997.22.1

WOOD CARVING IS A PASTIME often handed down within communities, inspired by observation of elders and individual exploration. For sculptor Vernon Edwards, this transmission occurred in both youth and adulthood. Born in Georgia, Edwards was exposed to woodworking through his father, a carpenter. Later, as a teen living in Cleveland, Ohio, Edwards met an elderly artist who showed the younger man his carved walking sticks. Edwards carved sporadically while working in Philadelphia, but he pursued his art in earnest in the 1980s after returning to his hometown of Pooler, near Savannah. There, he gradually filled his trailer home to bursting with extravagant writhing walking sticks resembling venomous snakes, informed by the real snakes he observed and the shapes of branches he gathered in nearby woods.

Edwards also visited the Savannah barbershop of wood-carver Ulysses Davis, whose sculptures had received national recognition by the 1980s through exhibitions at the Library of Congress and the Corcoran Gallery of Art in Washington, DC. Davis became a role model to Edwards and several other African American men sculpting with wood in the Savannah area. Inspired by Davis's wooden busts of historical figures, Edwards set about creating small portraits of prominent African Americans, among them Frederick Douglass and Harriet Tubman. Edwards's depiction of Tubman is perhaps the strongest of these, possessing an almost monumental intensity despite its small size. With her steely gaze and rifle held squarely in front of her, Edwards's Tubman clearly means business. Working in an isolated environment with occasional help from a relative and fellow wood-carver, Edwards created a body of work that reflected his pride of heritage and the power of personal creation. HD

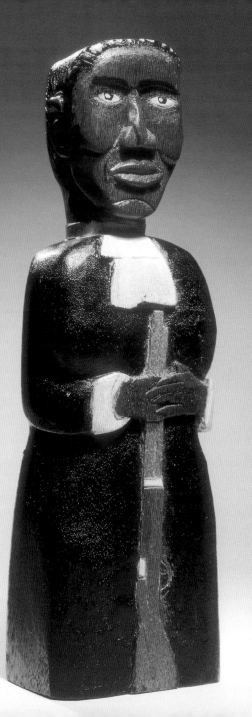

HESTER BATEMAN
British, 1708–1794

Sugar Basket, 1788
Sterling silver and glass, 4 × 5 × 3 ¾ in. (10.2 × 12.7 × 9.5 cm)
Gift of Frank A. Rizza, M.D., and family
2012.15.24.a-b

THOUGH THIS BASKET IS A lovely piece of artistry, it is not nearly as impressive as the woman who created it. Hester Bateman is perhaps England's most famous female silversmith. After the death of her husband in 1760, she registered her own mark in 1761 and managed to create beautiful pieces of silver, operate a successful business that lasted four generations, and raise six children, all in a world where women in business were a rarity. Bateman bridged economic classes throughout her life, moving from her poor and illiterate upbringing to a comfortable and secure life. She created widely popular pieces that were simple yet elegant, attainable by the middle classes yet offering beauty typically enjoyed by the wealthy elite.

This sugar basket, like most of Bateman's creations, was intended for dining and entertaining. Its cobalt blue glass interior offers a rich contrast to the silver basket and held sugar for sweetening tea and other foods. The handles on baskets allowed diners to pass food and condiments around the table rather than relying on waitstaff. Although sugar was first refined in India about six thousand years ago, it did not become widely available in Europe until European nations imported enslaved Africans into colonies in the Americas beginning in the sixteenth century. With the increased availability of sugar, tea, and coffee brought by expanding global trade and imperial slavery, the demand for silver domestic objects proliferated. Silversmiths like Bateman produced hundreds of types of hollowware and cutlery, limited only by the silversmith's imagination and their customers' finances. SBM

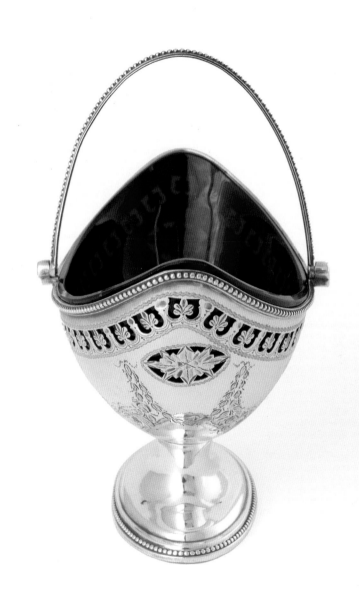

KAHLIL GIBRAN
American, born Lebanon, 1883–1931

Life, c. 1931
Watercolor and pencil on paper, 11 × 8 ½ in. (27.9 × 21.6 cm)
Gift of Mary Haskell Minis
1950.8.12

KAHLIL GIBRAN IS BEST KNOWN as the author of *The Prophet,* a book of poetry and fables first published in 1923. Since its publication, *The Prophet* has been translated into more than twenty languages and has notably never been out of print. Though lesser known than his writings, Gibran's involvement in the visual arts was vital to his personal expression; he produced watercolors, drawings, and oils from a young age. Some, like *Life,* were created to accompany the publications of his written works, while others were independently conceived works of art. *Life* is one of three works in Telfair's collection created to illustrate *The Garden of the Prophet.* In it, Gibran interprets Mother Earth as a larger-than-life female figure reaching down benevolently toward the small human figures surrounding her.

Gibran was born in Lebanon and moved with his family to Boston while he was still a boy. As a young man, he attracted attention from members of Boston's artistic circles, and he quickly became exposed to writers, photographers, visual artists, and patrons of the arts. Included in the latter category was Mary Haskell (later Minis), who ran a progressive school for girls in Boston's Back Bay. Haskell helped Gibran secure exhibition opportunities and sponsored his studies in Paris. They maintained an intense friendship throughout Gibran's life and after Haskell relocated to Savannah, she chose to donate her personal collection of Gibran's artwork to Telfair Museums. Comprising five paintings, eighteen watercolors, and six drawings, it is the largest collection of Gibran's visual art in the United States. CAM

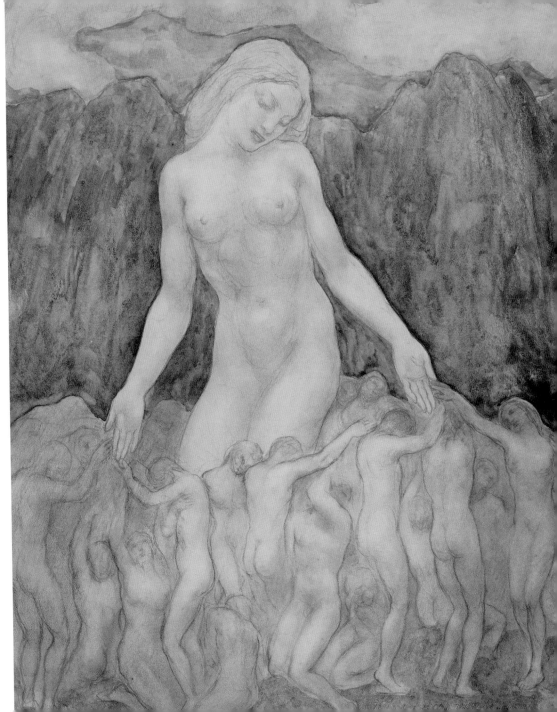

JAMES JEBUSA SHANNON
British, born United States, 1862–1923

George Hitchcock, c. 1892

Oil on canvas, 51 ⅛ × 35 ³⁄₁₆ in. (129.9 × 89.4 cm)

Museum purchase

1909.4

AMERICAN-BORN ARTIST James Jebusa Shannon left the United States at age sixteen to study art in London, and he would remain in England for the rest of his career. After being commissioned by Queen Victoria to paint portraits of her staff, Shannon cemented his reputation as a top society painter and was eventually knighted for his achievements. Shannon was highly sought-after for his elegant, flattering style, and the growing middle and upper classes of the period provided ample patronage for the young artist. His bravura brushwork inspired comparisons to Shannon's contemporary and chief artistic rival, John Singer Sargent.

Shannon's portrait of fellow artist George Hitchcock was painted near Hitchcock's home in the Dutch village of Egmond aan den Hoef. Shannon traveled to the rural artists' colony in the Netherlands several times, visiting his friends Hitchcock and Gari Melchers (who would later become Telfair's fine arts adviser and broker the purchase of this painting). In this informal portrait of an artist at work, Shannon shows Hitchcock outfitted in painting attire and a fashionable goatee, intently gazing at a canvas placed just beyond the viewer's sight. He has situated Hitchcock in a field of flowers, a fitting choice for an artist best known for his Dutch landscapes and views of the figure in nature. Hitchcock's trademark style is on full view in Telfair's painting *Early Spring in Holland* (see figure). CAM

ABOVE:
George Hitchcock
(American, 1850–1913)
Early Spring in Holland,
c. 1890–1905
Oil on canvas, 35 ⅞ ×
51 ¼ in. (91.1 × 130.2 cm)
Museum purchase
1908.5

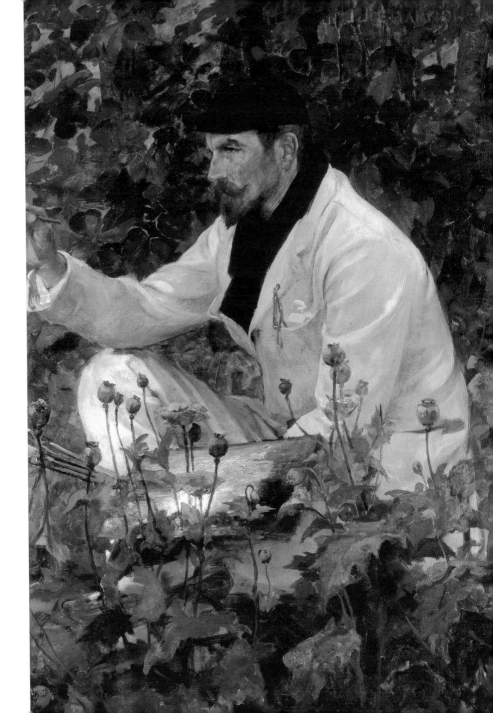

FRANK STELLA
American, born 1936

Bene come il sale, 1989

Etching, aquatint, and relief print on handmade paper, 75 ¼ × 59 in. (191.1. × 149.9 cm)
Kirk Varnedoe Collection, Gift of the Artist
2006.25

FRANK STELLA AND KIRK VARNEDOE are both iconic figures in the twentieth-century art world. As an artist who found a path forward after abstract expressionism, Stella became known for his geometric and minimalist works, which later evolved into prints that explored more expressionist forms through repetition. He was famously known for stating: "what you see is what you see." Savannah native Kirk Varnedoe took on the mantle of chief curator of painting and sculpture at the Museum of Modern Art in New York in 1988, a position he held until 2001. He is remembered for championing the work of living artists and found much to admire in Stella. In fact, Stella said he and Varnedoe bounced ideas off each other in a productively competitive way. He also emphasized how Varnedoe saw value in the "physical reality" of a work, which Stella found to be a refreshing quality in a curator.

Bene come il sale translates to "as dear as salt" and is a reference to a story in *Italian Folktales* (1954) by Italo Calvino, the twentieth-century Italian writer. Part of Stella's *Italian Folktales* series, the work takes imagery from his *Pillars and Cones* series and explores the narrative capacities of abstraction. The work's large scale and bold forms make it a perfect fit for the Kirk Varnedoe Collection, a group of works on paper by the artists Varnedoe most admired, which were donated to Telfair Museums to honor his life and legacy. ED

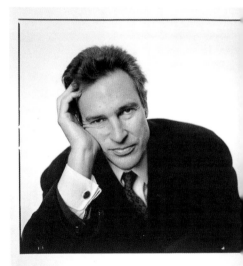

ABOVE:
Brigitte Lacombe
(French, born 1950)
Kirk Varnedoe, 1999
Gelatin silver print, 18 ×
in. (45.7 × 45.7 cm)
Kirk Varnedoe Collectio
Gift of Brigitte Lacombe
2006.16

This edition © 2021, Scala Arts Publishers Inc. in collaboration with Telfair Museums

First published in 2021 by Scala Arts Publishers Inc.
c/o CohnReznick LLP
1301 Avenue of the Americas,
10th Floor, New York
NY 10019
www.scalapublishers.com
Scala – New York – London

Distributed outside Telfair Museums in the book trade by
ACC Distribution
6 West 18th Street
4th Floor
New York, NY 10011

10 9 8 7 6 5 4 3 2 1
ISBN: 978-1-78551-315-2

Project manager: Claire Young
Copy editor: Magda Nakassis
Graphic design: Heather Bowen
Printed and bound in China

FRONT COVER: Frederick Carl Frieseke, *The Garden Umbrella*, (see pp. 66–67)
BACK COVER: Augusta Savage, *Gwendolyn Knight* (see pp. 8–9)
FRONTISPIECE: Henry Ossawa Tanner, *Untitled* (see pp. 34–35)

Library of Congress Cataloging in Publication Data: a catalogue record for this book is available from the publishers.

AUTHORS

ASB	Anne-Solène Bayan
CAM	Courtney A. McNeil
ED	Erin Dunn
HD	Harry H. DeLorme
SBM	Shannon Browning-Mullis

IMAGE CREDITS

Text and photography copyright © Telfair Museums, 2020, except as follows: pp. 4–5 © Atlantic Archives, Inc. / Richard Leo Johnson; p. 9 © Estate of Augusta Savage; pp. 16–17 © Ansley West Rivers; pp. 18–19 © Daniel B. Gelfand; p. 25 © Joseph Killorin; pp. 26–27 © Katja Loher; p. 29 © C. Schwabacher and B. Webster; 31 © 2020 The Jacob and Gwendolyn Knight Lawrence Foundation, Seattle / Artists Rights Society (ARS), New York; pp. 32–33 © Estate of Robert Gwathmey / Licensed by VAGA at Artists Rights Society (ARS), New York; pp. 38–39 © Sam Gilliam; pp. 42–43 © Bruce Davidson, 1959; p. 45 © Helen Levitt Film Documents LLC, courtesy Galerie Thomas Zander, Cologne; p. 47 © Frederick C. Baldwin; p. 53 © Carrie Mae Weems; pp. 54–55 © Nickolas Muray Photo Archives; p. 56 © Courtesy of the Georgia Historical Society, A-1361-084; p. 59 © Jack Leigh Estate; pp. 60–61 © 2020 Mickalene Thomas / Artists Rights Society (ARS), New York, printed and Published by Durham Press; p. 63 © Nick Cave. Courtesy of the artist and Jack Shainman Gallery, New York. Photo by James Prinz Photography; p. 70 © Estate of Vernon Edwards; p. 78 © Brigitte Lacombe; p. 79 © 2020 Frank Stella / Artists Rights Society (ARS), New York.

Every effort has been made to acknowledge correct copyright of images where applicable. Any errors or omissions are unintentional and should be notified to the Publisher, who will arrange for corrections to appear in any reprints.